THE LITTLE BOOK OF
SKETCHING

MORE THAN 100 QUIRKY AND CLEVER IDEAS FOR
SKETCHING YOUR WAY THROUGH DAILY LIFE

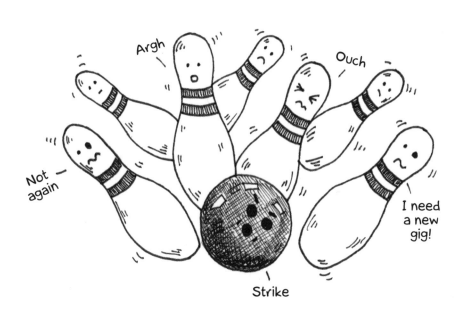

BY MATT ANDREWS

Brimming with creative inspiration, how-to projects, and useful information to enrich your everyday life, Quarto Knows is a favorite destination for those pursuing their interests and passions. Visit our site and dig deeper with our books into your area of interest: Quarto Creates, Quarto Cooks, Quarto Homes, Quarto Lives, Quarto Drives, Quarto Explores, Quarto Gifts, or Quarto Kids.

© 2017 Quarto Publishing Group USA Inc.
Text and artwork © 2017 Matthew Andrews

First Published in 2017 by Walter Foster Publishing, an imprint of The Quarto Group. 6 Orchard Road, Suite 100, Lake Forest, CA 92630, USA.
T (949) 380-7510 **F** (949) 380-7575 **www.QuartoKnows.com**

Walter Foster Publishing titles are also available at discount for retail, wholesale, promotional, and bulk purchase. For details, contact the Special Sales Manager by email at specialsales@quarto.com or by mail at The Quarto Group, Attn: Special Sales Manager, 401 Second Avenue North, Suite 310, Minneapolis, MN 55401 USA.

ISBN: 978-1-63322-393-6

Project editing by Stephanie Carbajal
Page layout by Erin Fahringer

Printed in China
10 9 8 7 6 5 4 3 2 1

Table of Contents

Introduction

Hello, fellow sketchers

The first thing we learn in school is to make messy pictures to adorn our parents' fridges. Some of us (me) carry on making pictures—hopefully not so messy. Everyone has the ability to draw.

Make some scribbles

I think sketching and doodling is great, and I'm guessing, since you're reading this, that you do too. I have my own style when drawing, and I want you to use all, or some, of this book to help you find your own style and way of sketching.

Let's have fun

I hope you enjoy working your way through the sketching exercises contained in these pages. I only have one rule—have fun and get drawing.

How to Use This Book

Each section of this book has a specific theme, with five exercises for you to follow and a couple of open pages where you can draw your own ideas based on the theme. There's also a handy creative prompt to help get your pens and pencils sketching and doodling.

In the step-by-step exercises, I'll show you how to break objects down into basic shapes, as well as how to draw using a grid, like the example below.

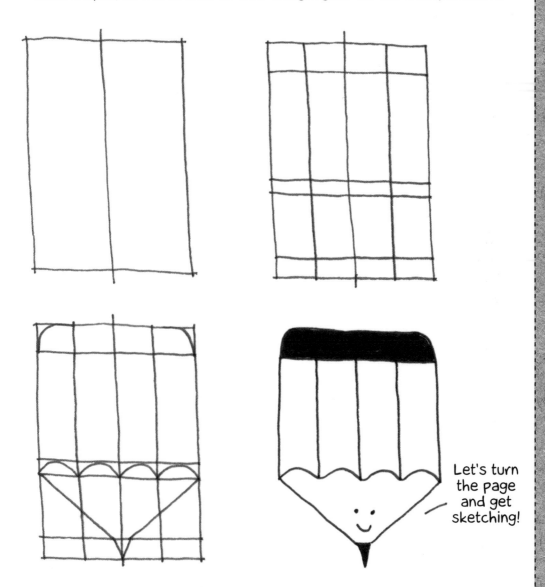

Let's turn the page and get sketching!

Supplies

Humans have been making pictures since the Prehistoric Age, and we've come a long way from spitting red clay into our hands against a rock when it comes to the materials we draw with. I have, and use, a lot of drawing implements, but it comes down to personal preference. For all my fancy implements, my tools of choice will always be a pack of sticky notes, a pencil, and a ballpoint pen.

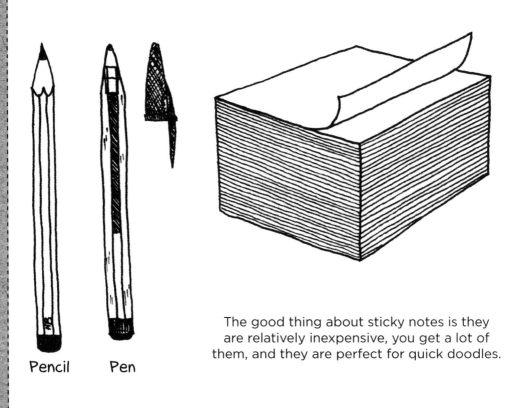

Pencil Pen

The good thing about sticky notes is they are relatively inexpensive, you get a lot of them, and they are perfect for quick doodles.

I'll keep
you sharp

Don't use me too much...
mistakes are great

Erase With Me

More toys to scribble with...

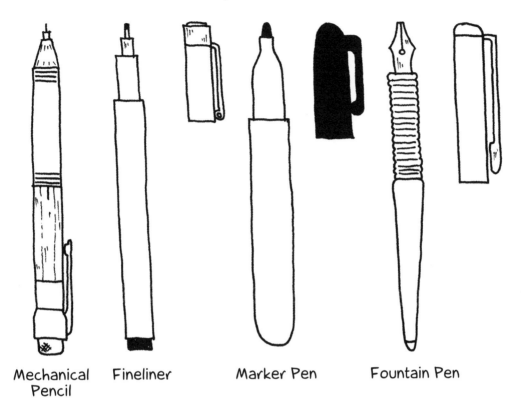

Mechanical
Pencil

Fineliner

Marker Pen

Fountain Pen

I use circle and
square templates as
guides, but keep the
drawings loose and
organic.

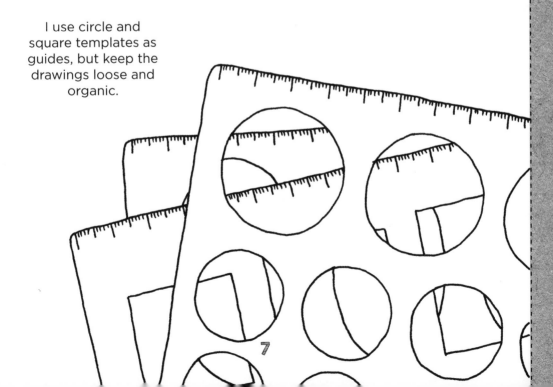

The World Is Your Oyster: Finding Material

Ideas can come from anywhere, especially when doodling rough, little sketches of silliness that make you smile.

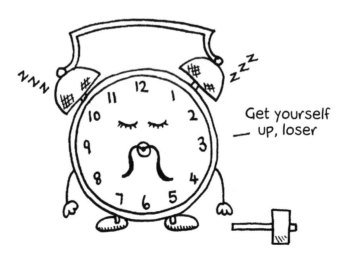

Even the mundane and everyday can inspire you!

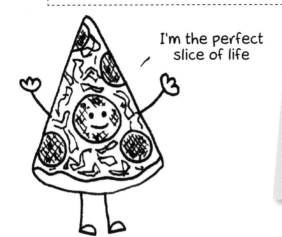

I'm the perfect slice of life

You can't go wrong with doodles of pizza.

In fact, food makes great subject matter for funny characters.

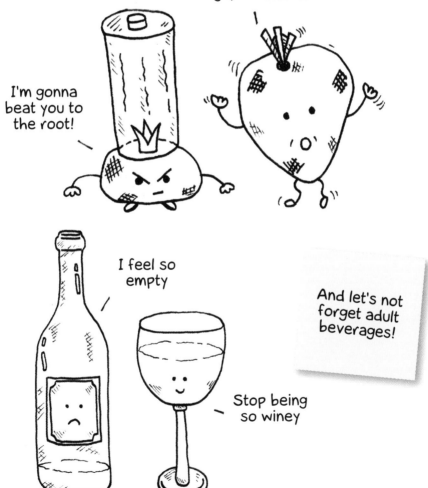

Argh, I'm blended!

I'm gonna beat you to the root!

I feel so empty

And let's not forget adult beverages!

Stop being so winey

You'd think they'd learn

Nope

Think about those holidays you enjoyed. (Sketching while skiing is not advised.)

Argh!

Have you ever thought about contacts?

No, why?

Or a trip to your local eye specialist.

Yeah, I'm listening

What about the objects we use every day?

Zzzz

Blah Blah Blah Blah Blah

You always turn me on

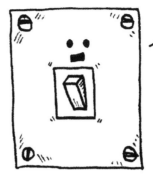

That's it. Just turn me off and walk away like you always do!

Don't press my buttons

Sketching while watching TV is a great way to get ideas. Now you can draw your own endings!

Can't we just watch reruns of Lost?

The best thing about sketching is that you can draw anything in your world. Nothing is ridiculous in the doodle world.

Let's get fruity

The world is
your oyster

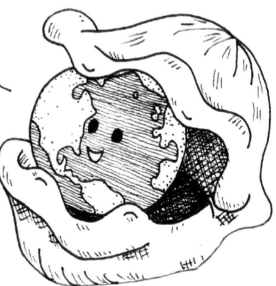

The most important thing is to have fun and give up controlling your imagination!

Pick any object that you can see right now, and sketch it with some character. What is it thinking? If it could talk to you, what would it say?

A Day in the Life

If you're new to sketching, start by drawing your way through a day, picking some of the little details from your daily life to doodle—let's start with a cereal box.

Don't mess with a cereal killer!

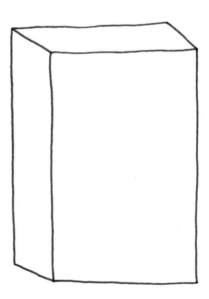

❶ Start by drawing a rectangle.

❷ Now add the sides to create a simple box shape.

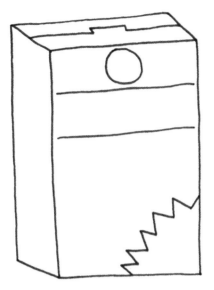

❸ Add a flap on the top. Add a circle for a logo, two lines for the name, and a burst.

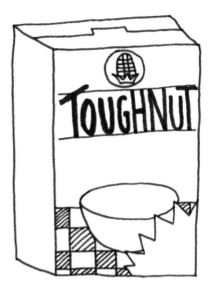

❹ Add a logo, and name your cereal. Draw a bowl and tablecloth.

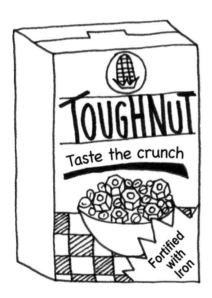

❺ Fill the bowl with the cereal of your choice, and add some taglines.

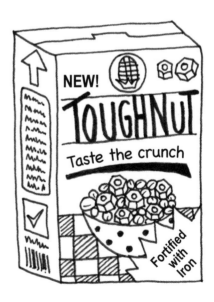

❻ Finish with some details, and you're done!

Coffee Break

Coffee and work practically go hand in hand, especially in this day and age. Let's draw some coffee cups—maybe while having a coffee.

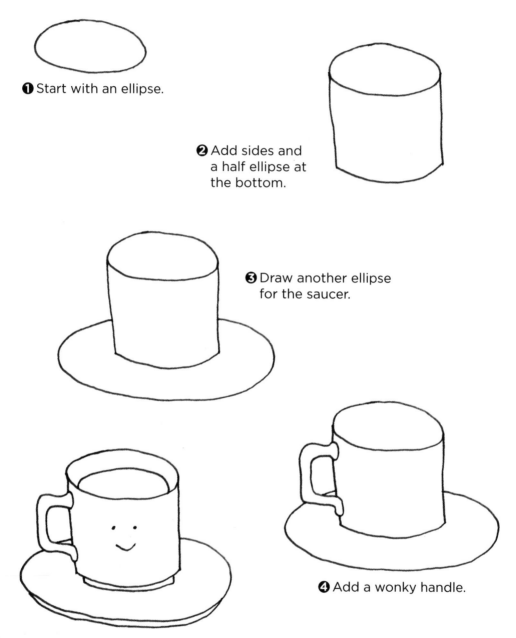

❶ Start with an ellipse.

❷ Add sides and a half ellipse at the bottom.

❸ Draw another ellipse for the saucer.

❹ Add a wonky handle.

❺ Draw a few more ellipses for the details. Try to see the object as a set of simple shapes, and drawing is easy!

Experiment with different ellipse sizes.

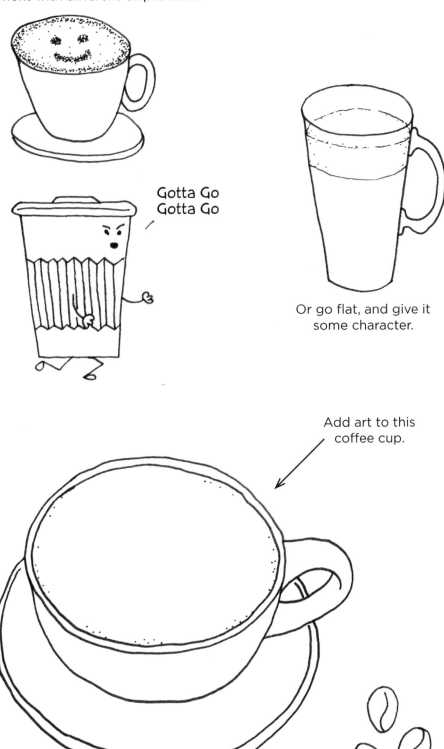

Gotta Go
Gotta Go

Or go flat, and give it
some character.

Add art to this
coffee cup.

A Trip to the Optician

Spectacles might seem challenging to draw, but remember that in sketching the imperfections add character to your drawings! Follow along and draw your own snazzy glasses.

❶ Start with a circle.

Then add another one.

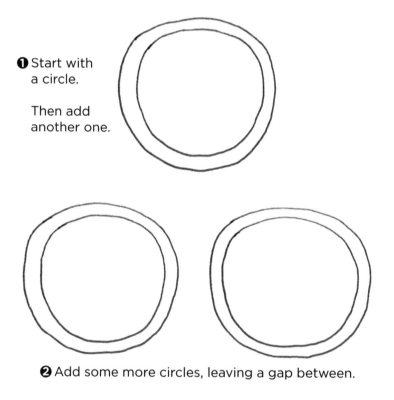

❷ Add some more circles, leaving a gap between.

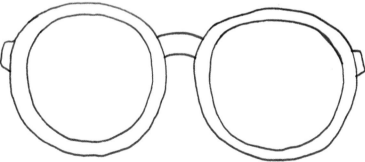

❸ Join the circles with a bridge, and add detail for the arms.

4 Decorate your glasses with a pattern, or bedazzle them with some jewels.

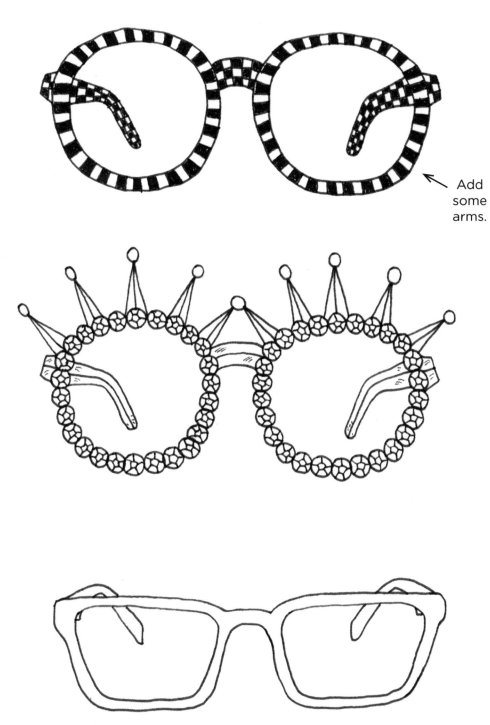

Add some arms.

Give these glasses some bling!

A Quick Drink with Friends

The next time you're at happy hour, sketch some cocktails.
Napkins make a great sketching surface!

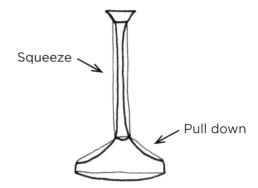

Squeeze

Pull down

❶ Start with a glass stem.
Think about the simple shapes
that make up the glass.

❷ Now taper the shapes
to look more realistic.

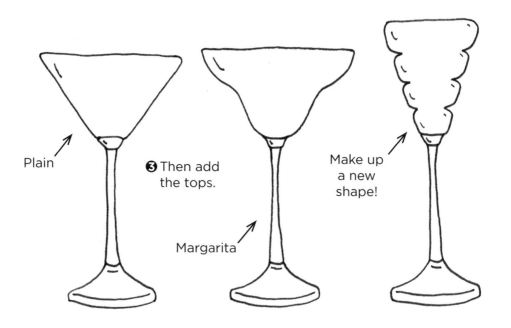

Plain

❸ Then add
the tops.

Margarita

Make up
a new
shape!

Again, think about the simple shapes, and then bend and
squeeze the lines to create the glass.

For this cocktail, draw a big glass (more drink!) with a smaller stem.

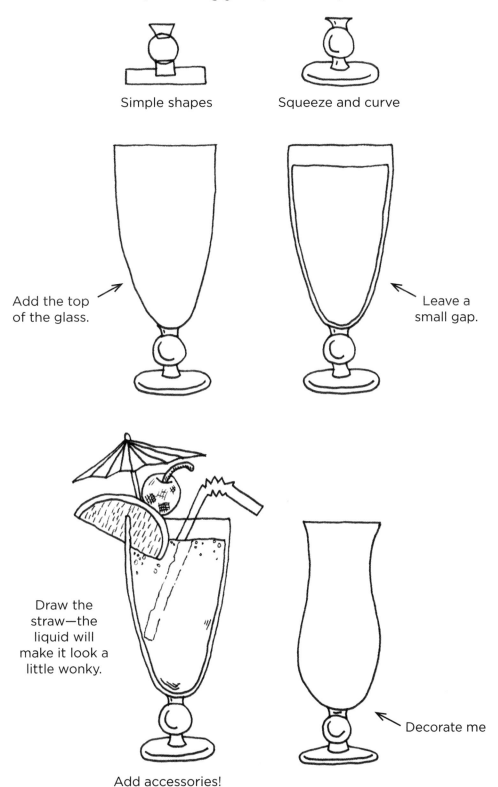

Simple shapes

Squeeze and curve

Add the top
of the glass.

Leave a
small gap.

Draw the
straw—the
liquid will
make it look a
little wonky.

Decorate me

Add accessories!

Time for Bed

It's the end of the day, and you're watching some late-night television when a breaking news story comes on. Let's get sketching!

❶ First draw a retro TV. Map out the shapes.

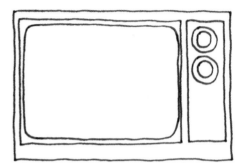

❷ Add a screen and dials.

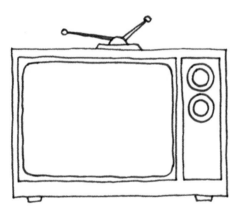

❸ Add an aerial and feet.

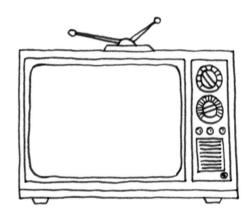

❹ Finish with details.

❺ Now draw a news anchor with exaggerated features.

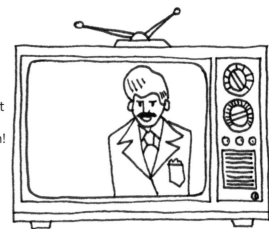

❻ He looks right at home there on the small screen!

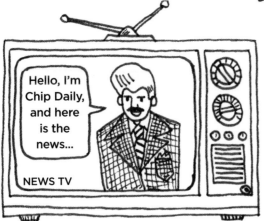

Hello, I'm Chip Daily, and here is the news...

NEWS TV

❼ Add finishing touches.

Today, _____ _____
from planet _____,
won the universe
mega _____.
When asked what
they would spend
the _____ on,
they said a giant
_____ for their
_____!

NEWS TV BREAKING NEWS

Think about adding your own news story, or try this sketching project with different news anchors.

Use these pages to sketch the everyday things in your life. Anything makes a good subject, from the pen or pencil in your hand to your pillow or coffeemaker. The sky is the limit!

Sketching for Stress Relief

Life is stressful! Whether it's that deadline at work, flying for the first time, buying a house, taking your child to the doctor, a driving test, a credit card bill, or trying to decide what to wear to that party on Friday... We humans have a knack for inviting stress into our daily lives.

Fears are a natural part of life.

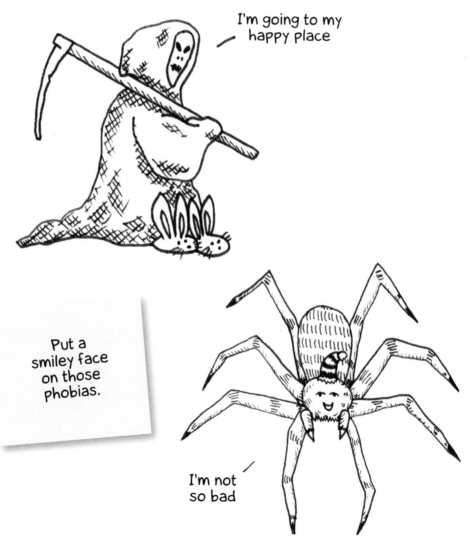

I'm going to my happy place

Put a smiley face on those phobias.

I'm not so bad

None of us likes going to the dentist.

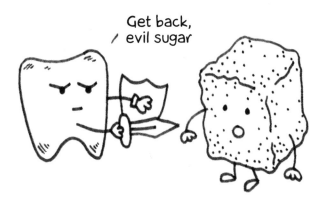

Get back,
evil sugar

Least of all,
your teeth.

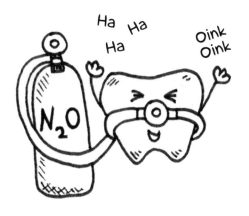

Ha Ha
Ha

Oink
Oink

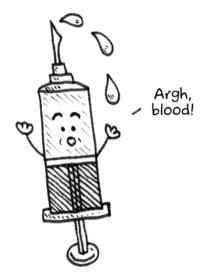

Argh,
blood!

The doctor's office can be
just as nerve-racking.

Yeah
right

CURE FOR
SARCASM
ONE A DAY

What if airplanes were afraid of heights?

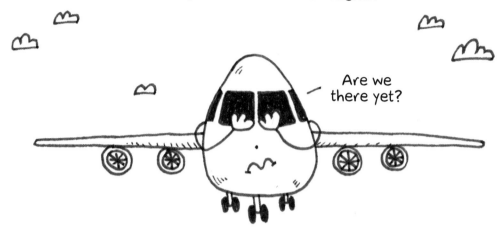

Or elephants really were
scared of mice?

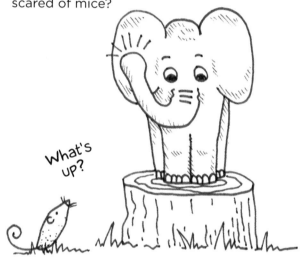

Sometimes
I feel
unworthy

We all have moments of doubt.

Doodle some repeating patterns to distract your mind.

How about some paw prints?

Even blobs with happy faces can be relaxing!

What do those butterflies in your stomach look like?

Party
on

Writing this book is pretty stressful.
Don't worry, I'm nearly finished.

OUT IN

Ctrl

Take
CTRL

If we didn't feel
stress, we'd get
nothing done! You
just have to sketch
your way through it.

Think about something you have to do in the next few
weeks that makes you anxious, and sketch it here.

Add some
smiles!

Dr. Tooth

What better way to help fight those stress monsters than to put a smiley face on them? Let's do some happy sketching—no sad faces allowed!

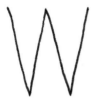

❶ Think of a tooth as a capital "W."

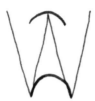

❷ Create an arc at the top and bottom.

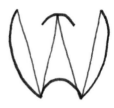

❸ Pull out and curve the sides of the "W."

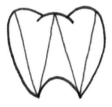

❹ Draw two arcs to join the sides to the middle.

❺ Erase the "W."

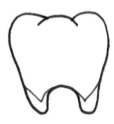

❻ Pull down and curve the bottom points.

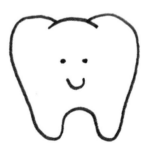

❼ Draw a happy face.

For some variation, flip the top curve to create a new tooth shape.

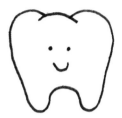

Think about the expressions and accessories you can add to your teeth.

I got arms

Give these teeth some happy faces!

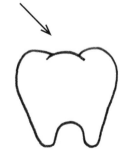

The Big Speech

Talking in front of people can be a daunting task. Thinking that everyone in the crowd is naked is a popular piece of advice, but it can be even more funny to imagine everyone in crazy outfits. Let's sketch an audience to present to.

❶ Start with basic shapes.

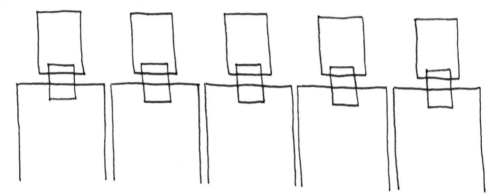

❷ Now add some curves, adding variation.

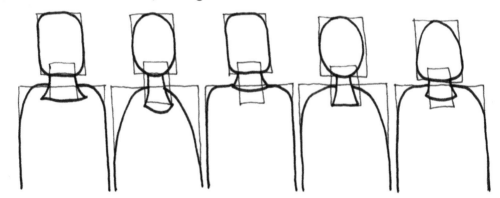

❸ Erase the lines you no longer need.

❹ Add some hair, arms, and facial features.

❺ Accessorize!

Finish drawing this cast of characters.

I BELIEVE

Gotta Pass That Test

Books are wondrous things, full of magic, excitement, love, mystery, and generally cool stuff. They can also be full of stuff we have to read to pass tests: physics, algebra, medicine, law, politics, business, etc. If books could talk... what would they have to say?

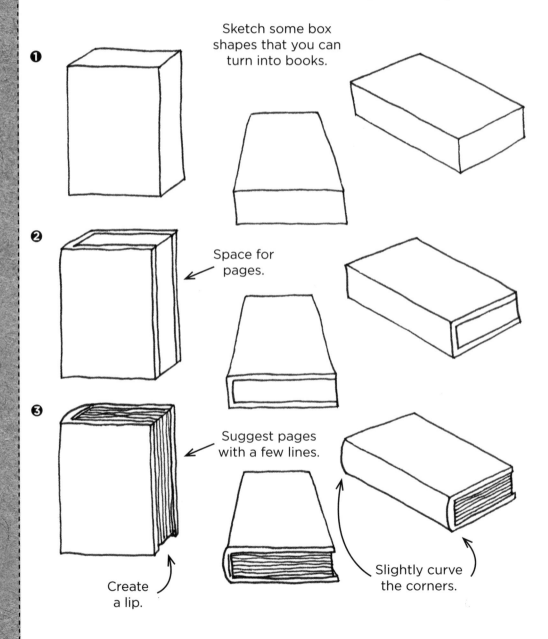

Sketch some box shapes that you can turn into books.

❶

❷ Space for pages.

❸ Suggest pages with a few lines.

Create a lip.

Slightly curve the corners.

❹ Now add character to your books.

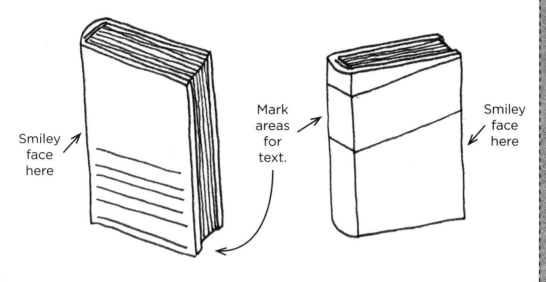

Smiley face here

Mark areas for text.

Smiley face here

❺

I am the sun and Juliet is the moon

You're hot

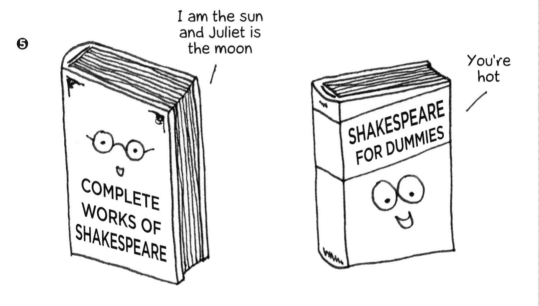

COMPLETE WORKS OF SHAKESPEARE

SHAKESPEARE FOR DUMMIES

Don't worry about being too precise with the text—
there's no need for perfection.

Experiment with different angles for your books,
and try out different thicknesses.

Just a Little Blood

None of us enjoys visiting the doctor. We get poked, prodded, and jabbed into submission for a whole host of ailments that usually results in a little bottle of get-well pills. What would your ideal cure be? Let's sketch some fantasy medicine.

❶ Bottle 1
Use only rectangles.

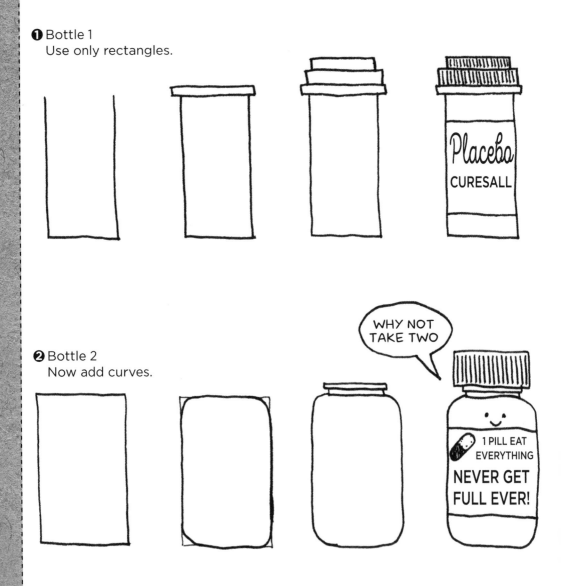

❷ Bottle 2
Now add curves.

Think about what your pill bottles would say if they could talk. Add some faces!

❸ Bottle 3

A dropper bottle: Start with rectangles. Then curve up and down with ovals to make the bottles three-dimensional.

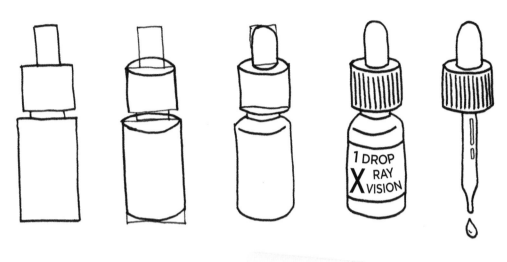

❹ Finish these bottles.

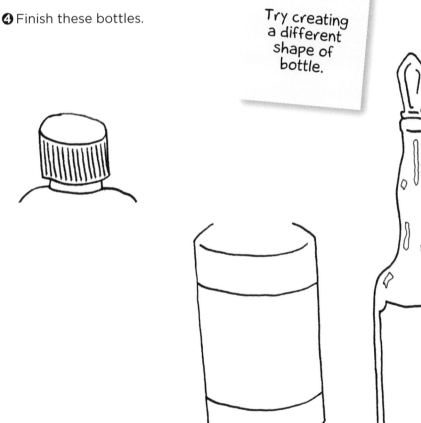

Try creating a different shape of bottle.

What elixir is in this bottle?

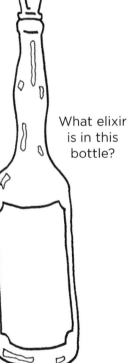

Up in the Air

For some, there is nothing more stressful than flying in an airplane—especially as it seems to defy the laws of gravity. Only Superman should be up amongst the clouds!

Start with an egg shape. Then add a tail, windows, and wheels.

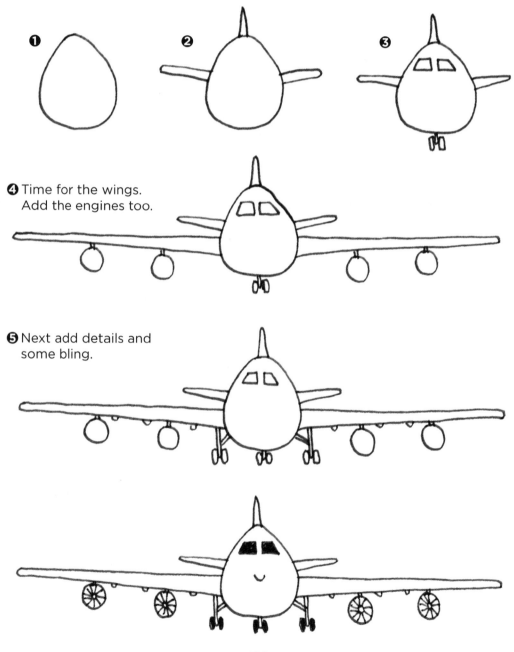

❹ Time for the wings. Add the engines too.

❺ Next add details and some bling.

❶ Draw a tapered sausage shape that is narrower at one end.

❷ Add a tail and wings.

❸ Then add some engines and windows.

❹ Add your own decals and decoration if you like!

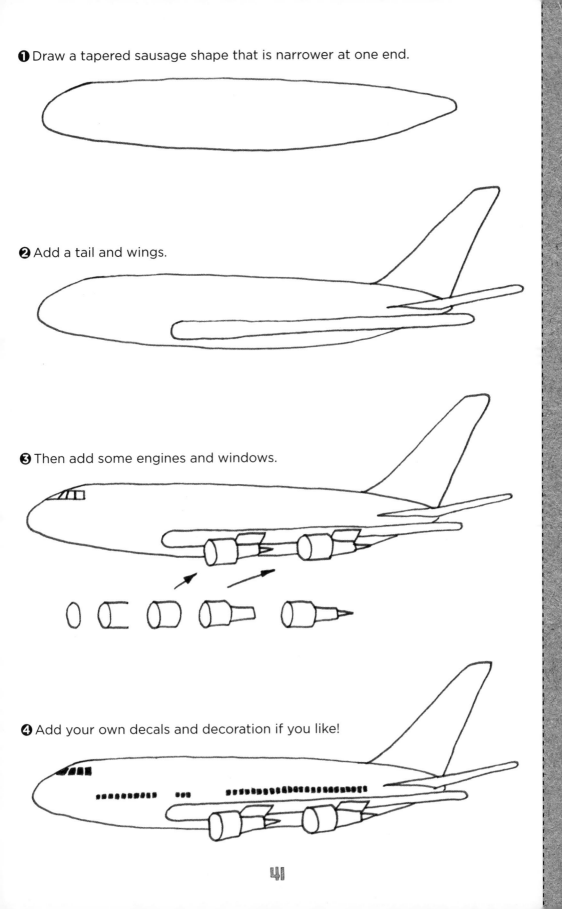

Use these pages to sketch some of the things that stress you out. You may find that you feel a little more relaxed after putting a funny, lighthearted spin on things!

Sticky Note Sketching

So you're at your desk at work/college/home with a pack of sticky notes that you use for reminders, appointments, phone numbers, etc. I use them for all of those things, but what I mainly use them for is doodling. They are perfectly sized squares of paper for housing little sketches and quick doodling.

Whether you're trying out a new pen...

...or watching funny videos on your laptop.

Maybe you're waiting on an important call...

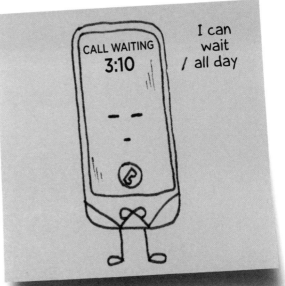

...or adding up your finances...

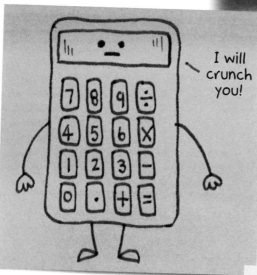

...or even just daydreaming about the weekend.

When you're in the office, look around at the objects you see every day.
Make them into funny little characters.

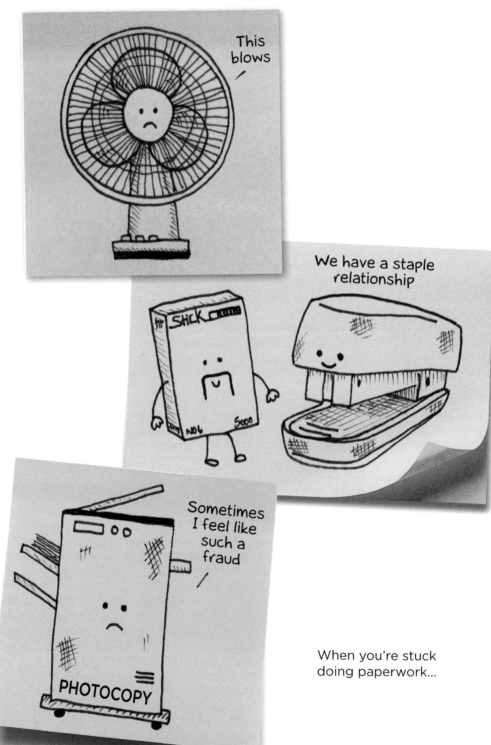

This blows

We have a staple relationship

Sometimes I feel like such a fraud

PHOTOCOPY

When you're stuck doing paperwork...

...or in the mail room...

...or thinking about being somewhere else.

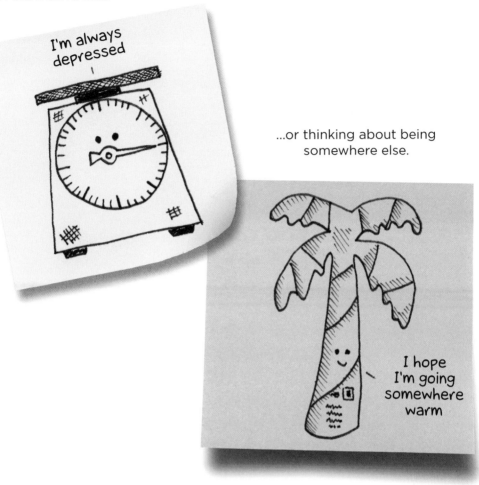

Coffee, coffee, coffee!

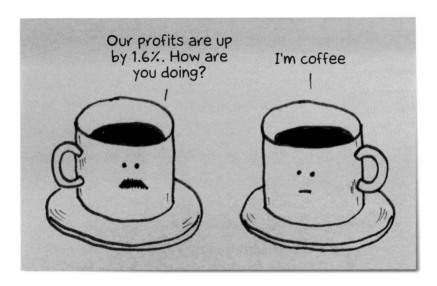

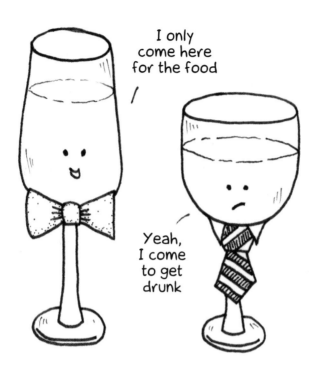

A sticky note pad is small enough to take anywhere.

At last it's Friday!

Using a sticky note pad (or the sticky notes below),
doodle what's on your desk or table.

On a
Conference Call

In the office, using the telephone is still a big part of the working day, so let's start our sticky note sketching exercises with some telephone doodling. All you need are some sticky notes and a ballpoint pen.

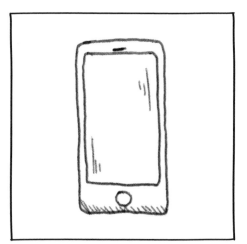 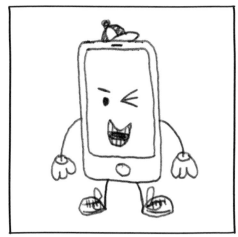

Mobile phones are quite easy to draw, but boring. Add some character!

 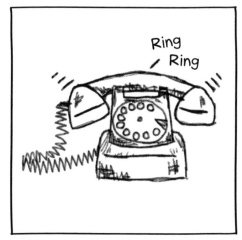

Try drawing something a bit more retro. Remember to keep it loose, and scribble with your ballpoint pen.

Go old school.

Flip the phone, and create a pair.

Mix and match telephones.

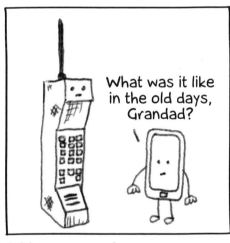

Add some speech.

Draw your phone creations here.

Friday Afternoon Meetings

So, you're in a long Friday afternoon meeting looking out of the high-rise window at all the other office buildings. Let's do some doodling of office buildings and see what we can turn them into.

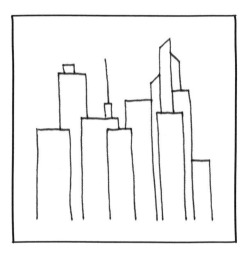

❶ Start by mapping out a simple city skyline. Think about what you want your buildings to look like.

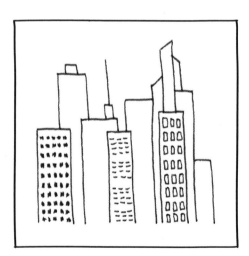

❷ Using different marks, start suggesting windows. Keep it loose.

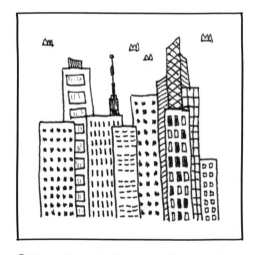

❸ Vary the window spacing, and add more details.

❹ Now take a couple of buildings and create a scene with them. Draw one building taller than the other, and then add details.

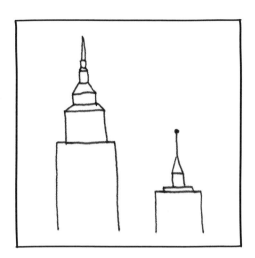

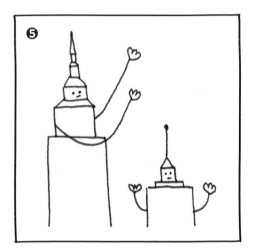

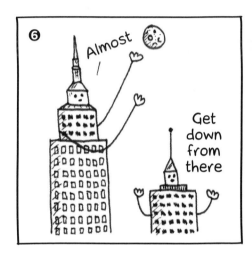

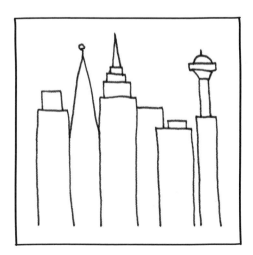

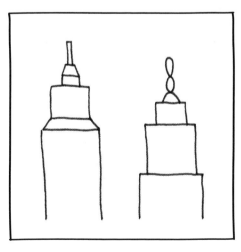

Finish these doodles.

A World of Stationery

If your office supplies could talk, what would they say about you? The pen tops that get nibbled on, the paper clips that end up in the vacuum, the sticky notes that get scribbled on and thrown in the bin. (Please remember to recycle...paper doesn't grow on trees.) One great thing about drawing on sticky notes is that you can use them to create your own little comic. Try it, and create a stationery scene.

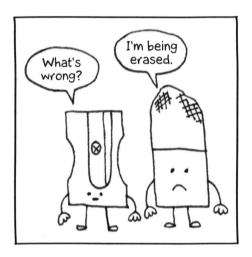

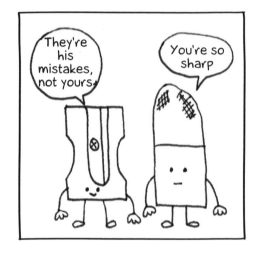

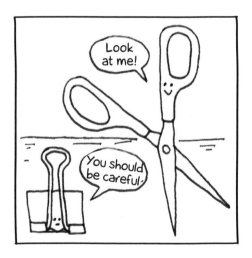

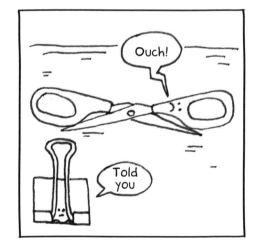

❶ Now create a three-note story. Because sticky notes are thin, you can trace the previous doodle onto the next note to maintain consistency.

Draw your stationery comic strip here.

Going Postal

In an age of online retail shopping and 24-hour delivery services, we send more parcels than ever. What if that company we all know and use (the one with the smiley arrow) didn't have any boxes, and everything had to be individually wrapped and shipped in the shape they are? Let's do some posting!

❶ Let's take an object like this printer, and wrap it for posting.

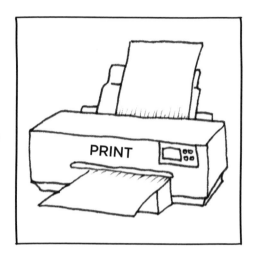

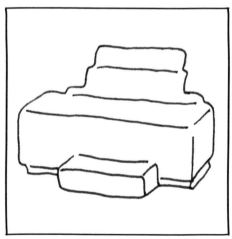

❷ Outline the object.

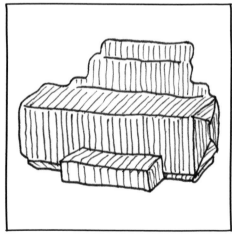

❸ Start wrapping.

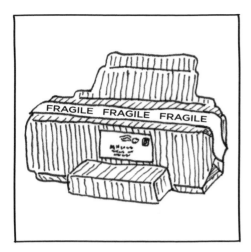

❹ Don't forget to add a label and some "Fragile" tape to finish off. You can use this technique to wrap anything.

❺ What about wrapping up a dog for posting? How would you cover the dog with brown paper?

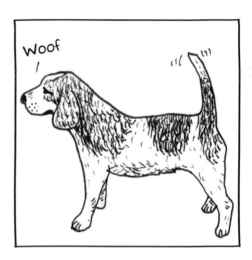

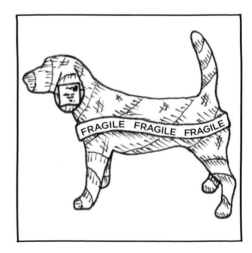

❻ Try wrapping this pooch.

*Never send animals through the post. Give them money for the bus.

The Big Business Function

The tuxedo. The dress. The canopies. The free, watered-down drinks. Welcome to the end-of-the-year office party. Instead of dressing up yourself for the occasion, let's dress the drink glasses for the night.

❶ Start with the glasses. Use basic shapes to get the general glass shape in place.

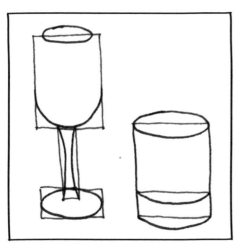

❷ Add ellipses.

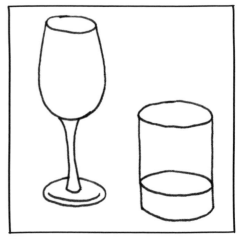

❸ Add the finishing details.

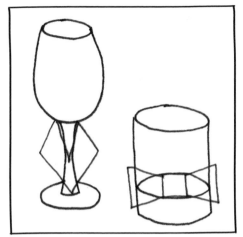

❹ Now that we have our drinking glasses, let's give them some character and dress them up.

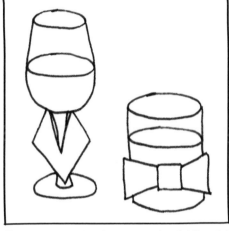

❺ Clean up the lines, and add liquid to the glasses.

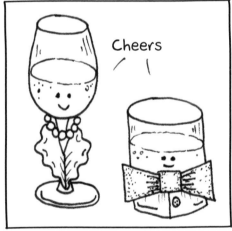

Cheers

❻ Finish off with a couple of smiles.

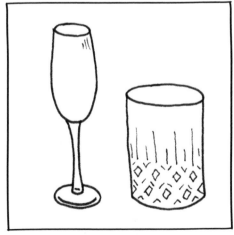

Dress up these glasses.

Use these pages to sketch some of the common items
and occurrences in your work life.

With Friends & Family

Spending time with family and friends provides endless opportunities for sketching. All the downtime activities that keep us sane enough to deal with work, school, and the responsibilities of life are a great source of doodling inspiration!

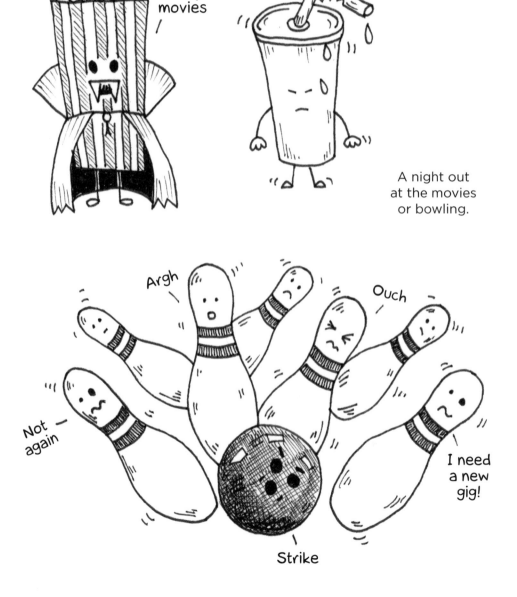

I love scary movies

Gulp

A night out at the movies or bowling.

Argh

Ouch

Not again

I need a new gig!

Strike

Make sure you've packed everything!

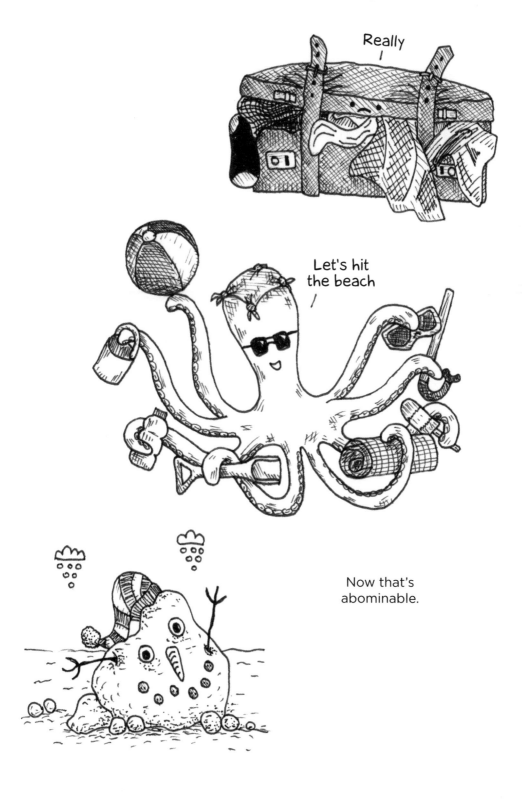

Really

Let's hit
the beach

Now that's
abominable.

Lots of holiday get-togethers...

What about
those fancy
dress parties?

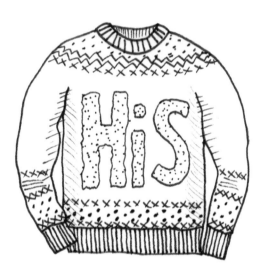

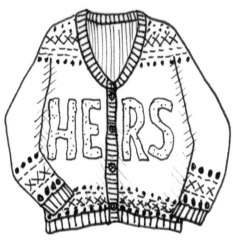

Go forth
and multiply.

graduations...

birthdays...

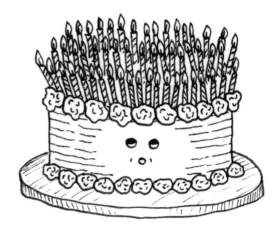

Let's
envelope

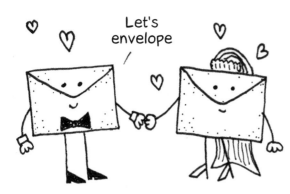

... and weddings!

We laugh, we cry, we argue,
we make up. Our family and
friends give us so much to
feel happy about.

Let's
celebrate

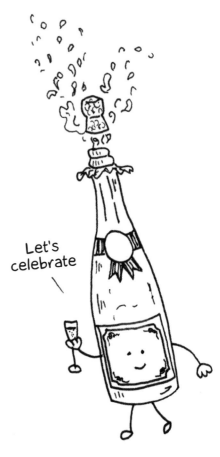

Draw your favorite family or friend gathering here.

All About Baby

Family starts with babies. We were all one once. Cute little dribbling, crying, pooping bundles of joy that, by the age of two, think they are the most important person in the world. Well, let's give them some adult jobs to do and see how they get on...

❶ Babies have big heads.

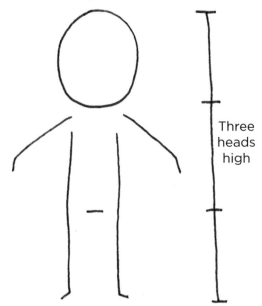

Three heads high

❷ And smallish bodies.

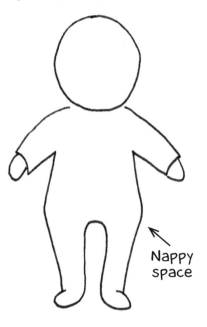

Nappy space

❸ They have big eyes.

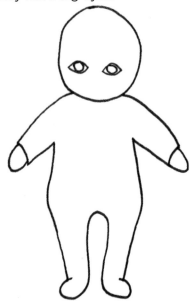

❹ And small features.

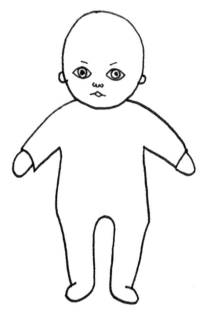

What jobs shall we give these babies to do?

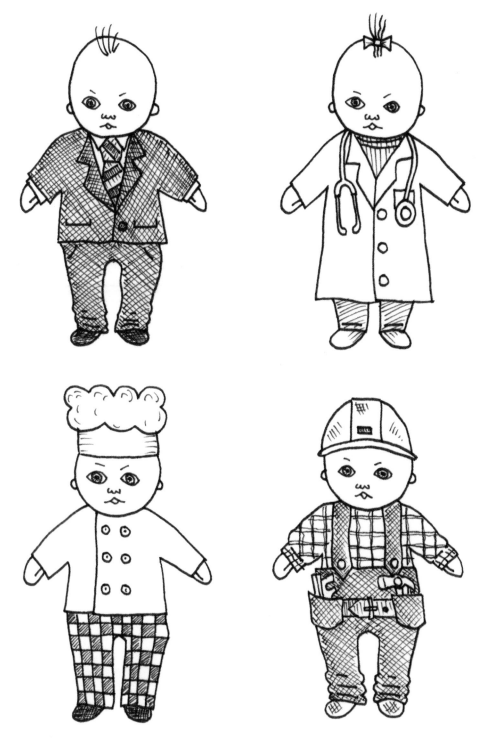

Draw appropriate work wear for an important job on the finished baby on page 68.

Matching Sweaters

There is nothing more unfashionably fashionable than the ugly Christmas sweater. The idea of wearing the boldest, most over-the-top, garish jumper to the Yuletide Party has become as popular as mince pies and mistletoe. Let's draw some ugly sweaters!

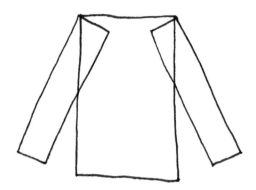

❶ Start with basic shapes.

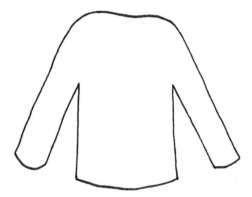

❷ Add some curves.

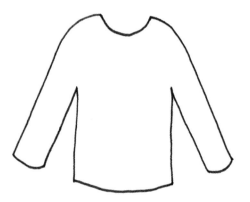

❸ Add a neckline.

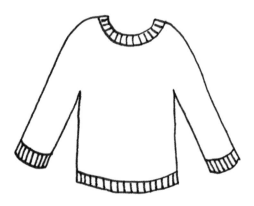

❹ Then add finishing details.

Now that you have your sweater, add some decoration.

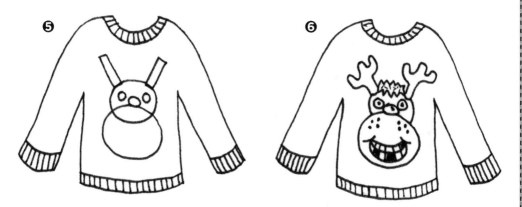

Start with basic shapes for the motif, and then create the character.

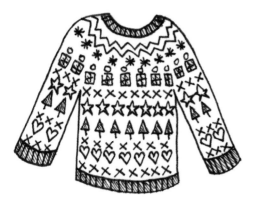

What about a funky Christmas pattern?

You can add variation to the shape of your sweater to create more designs.

Decorate these sweaters.

Season's Greetings

We've all had the family reunion (normally at Christmas) that has us meeting long-lost relatives that we never knew existed. How strange and unique our families can be! Let's take the sweater you just created and sketch a goofy relative to wear it.

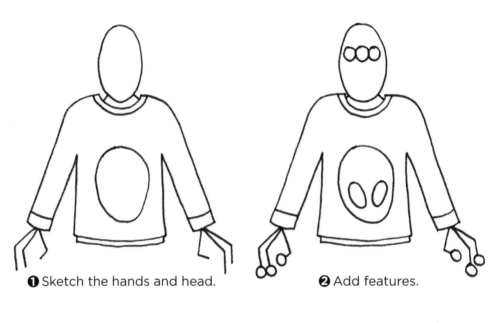

❶ Sketch the hands and head. ❷ Add features.

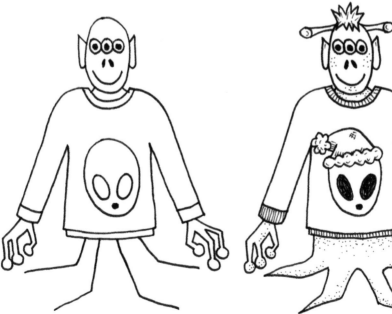

❸ Flesh out the fingers and face. ❹ Repeat for the legs.

What does your alien relative look like? Draw them here!

A Day at the Beach

Who doesn't love a family outing to the beach? Splashes in the sea, drinking warm lemonade, getting sand in your bits, falling asleep in the sun (ouch), and building sand castles... Let's do some beach doodling.

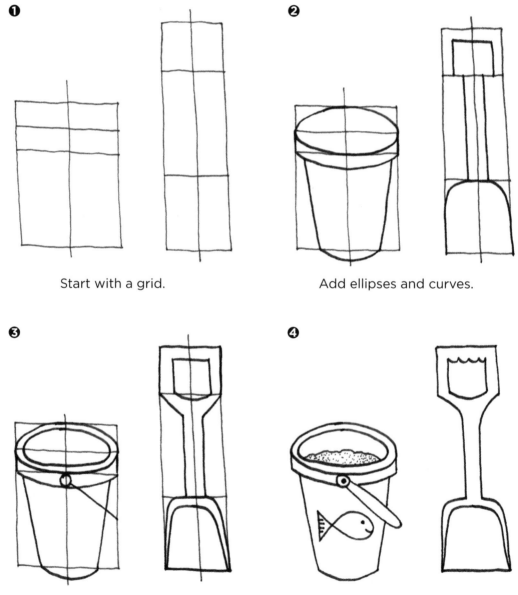

① Start with a grid.

② Add ellipses and curves.

A centerline helps you approximate and achieve proper proportions. Keep it sketchy, and draw your grid freehand—no intimidating rulers!

❺ Now think about other objects you can sketch using a grid. How about a Popsicle, a beach ball, or a twirly pinwheel?

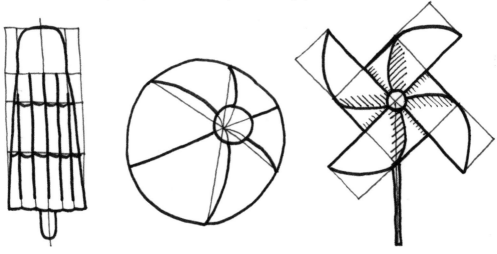

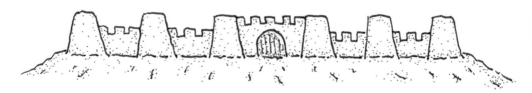

Finish off this sand castle scene. Consider marking everything with a grid, but keep it loose. After all, it's sand!

The Big Day

One of the most joyous occasions that we all come together to celebrate is a wedding. Friends and family all under one roof, plenty of rich food, copious amounts of alcohol, speeches, and dancing. What could possibly go wrong? For this sketching exercise, let's focus on delicious wedding cakes.

❶ Start with a simple three-tiered cake.

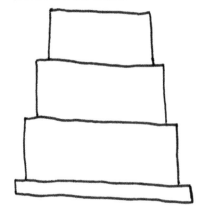

❷ Add traditional decorations.

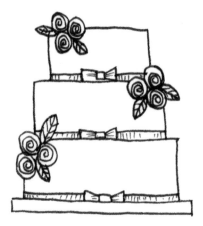

❸ Now make the same cake, but three-dimensional.

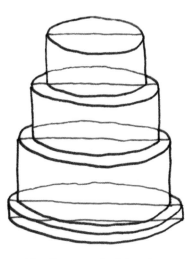

❹ Think of some not-so-traditional decorations to add.

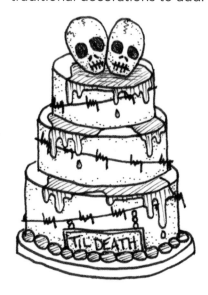

You know what to do.

❺ Now try creating some different shapes of cakes.

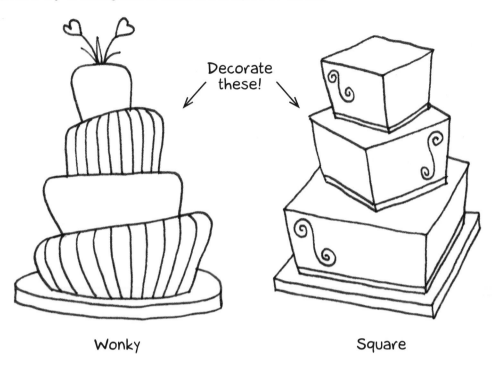

Decorate these!

Wonky

Square

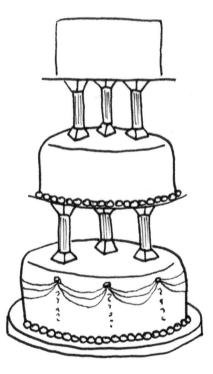

Finish decorating this fancy columned cake.

Draw your cake here.

Use these pages to sketch more crazy wedding cakes or
other kinds of celebration-worthy desserts.

Travel: Not Just the Destination

We spend a lot of time traveling. Whether it's sitting on a bus or train, stuck in traffic on the freeway, up in the air, or even just walking up and down the stairs at work, we're always on the move.

Think about the different modes of transport and places you visit...

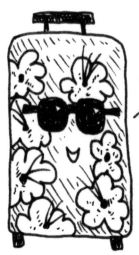

I'm off to the Bahamas. What about you?

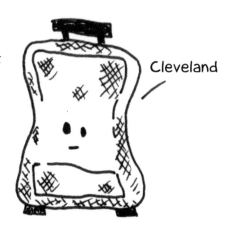

Cleveland

By air...

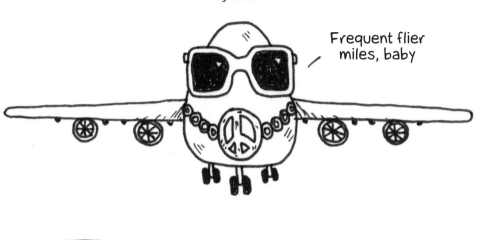

Frequent flier miles, baby

You people make me sick

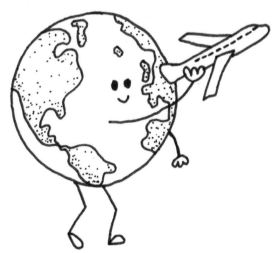

By sea...

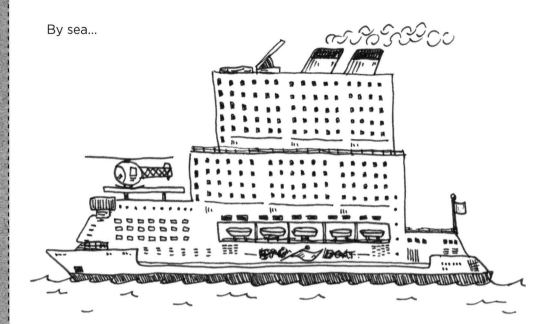

Let me
be your
anchor

Moooo!

By road...

The wheels on the bus

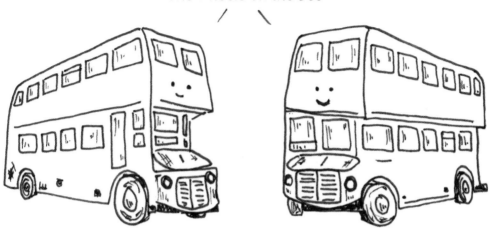

And rail...

All aboard

What about other forms of transport?

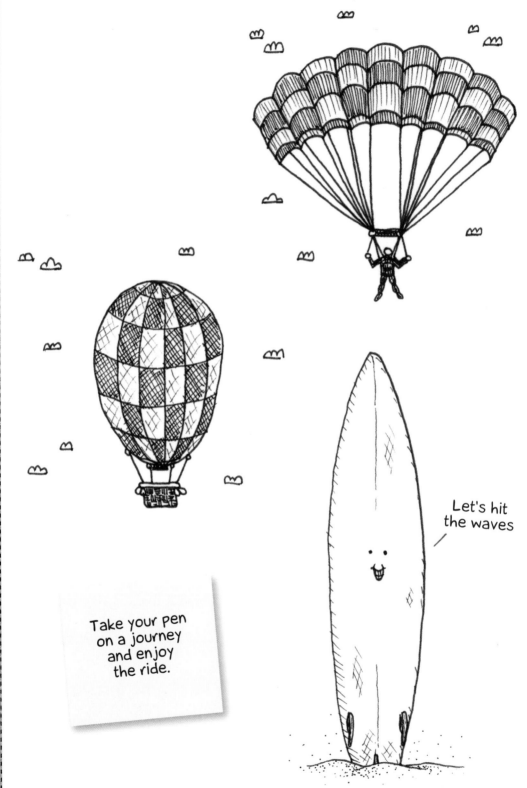

Let's hit
the waves

Take your pen
on a journey
and enjoy
the ride.

Think about a familiar journey and how you get there,
and then draw it here.

Don't You Just Love Airports?

Millions of people trudge through airports every day. That's a lot of luggage flying all around the world, off on their holidays and business trips. While all luggage is obviously functional, most of it is pretty boring. Let's give our luggage a makeover.

❶ Start with a standard luggage design.

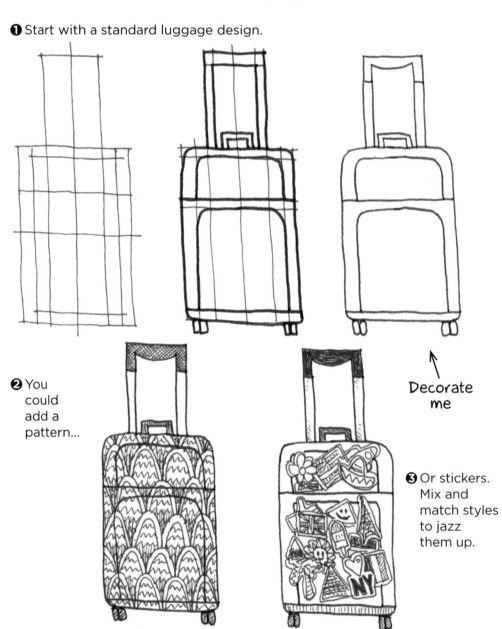

❷ You could add a pattern...

Decorate me

❸ Or stickers. Mix and match styles to jazz them up.

What if we change the shape of the luggage?

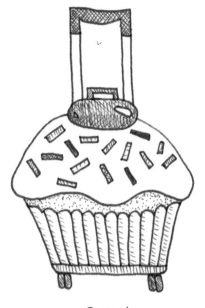

Cupcake

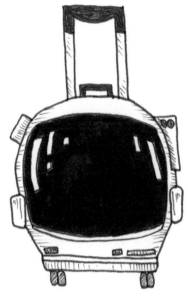

Astronaut helmet

Draw your luggage
design here.

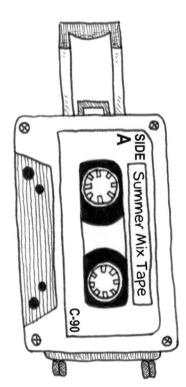

Cassette tape

I Wish I Were a Bus Driver

Buses come with all manner of modern conveniences. Toilets, beds, Wi-Fi, fridges, TVs, Jacuzzis. (Don't know about that last one, but I wouldn't be surprised!) One of the most iconic of all is the red, double-decker London bus. Let's create a poster using this classic red bus.

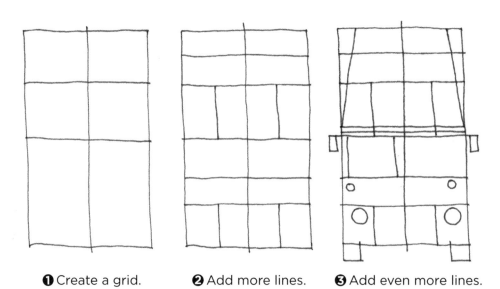

❶ Create a grid. ❷ Add more lines. ❸ Add even more lines.

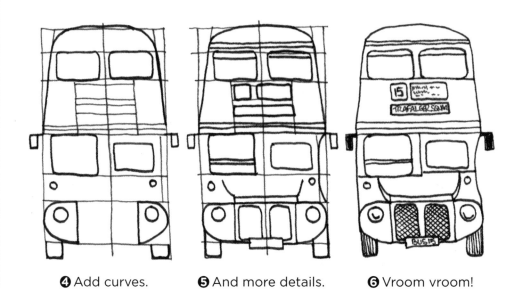

❹ Add curves. ❺ And more details. ❻ Vroom vroom!

Finish off this poster. Add people in the windows and a driver.
Where is the bus headed, what number is it, and what does the
license plate say? Don't forget to draw a background!

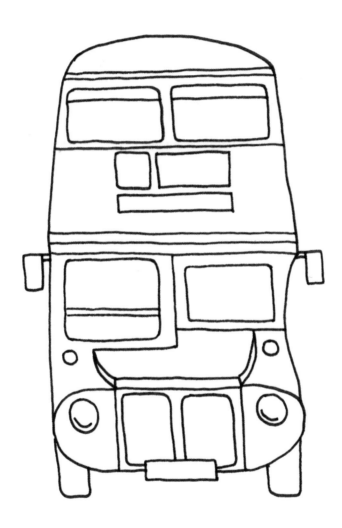

Stuck in Traffic

Motoring on the open road is great—under the speed limit, of course—but most driving takes place in towns and cities, which means sitting in our cars in traffic jams. What are these holdups? What is the obstruction?

❶ Let's set the scene.

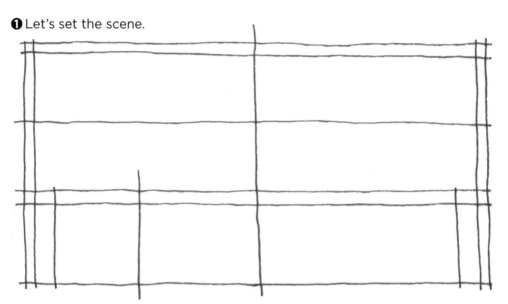

Draw a windshield and dashboard view, sort of like a movie or comic strip frame.

❷

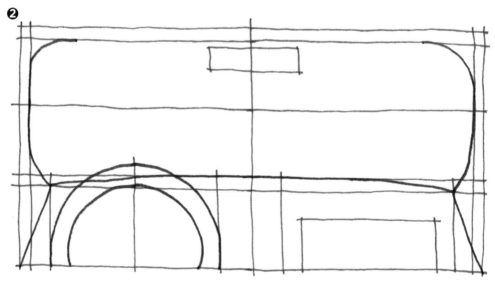

Map out the windshield, steering wheel, and rearview mirror.

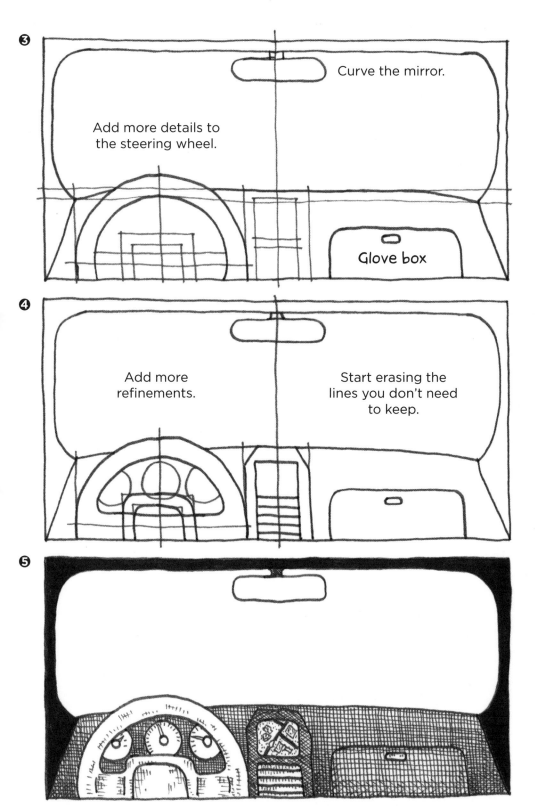

❸ Curve the mirror.

Add more details to
the steering wheel.

Glove box

❹ Add more
refinements.

Start erasing the
lines you don't need
to keep.

❺

Draw what you can see out of the windshield and rearview mirror.

91

Airborne

Before there were airplanes and helicopters and gliders and rocket ships, we had the recreational pursuit of going up and down in hot air balloons. It might not get you to where you want to go, but drawing them can be a lot of fun—with endless decorating possibilities!

❶
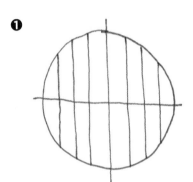

Draw a circle and divide it into eight equal parts.

❷
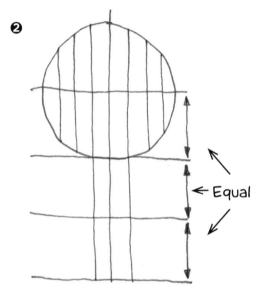

← Equal

Extend the middle lines down.

❸
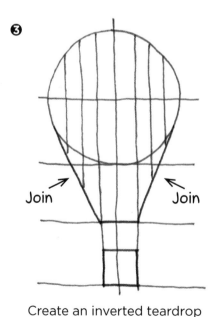

Join Join

Create an inverted teardrop shape and basket.

❹
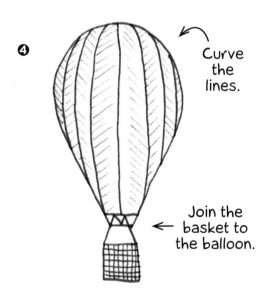

Curve the lines.

Join the basket to the balloon. ←

❺ Now decorate the hot air balloon.

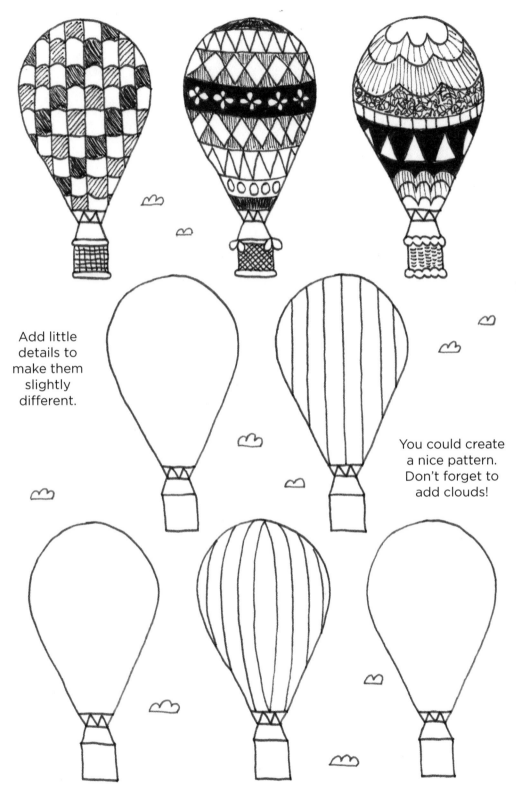

Add little details to make them slightly different.

You could create a nice pattern. Don't forget to add clouds!

One Foot in Front of the Other

Now for the oldest form of transport...the one we have had since the beginning—our feet! At least now there is a range of footwear to adorn our tootsies with. I wonder what the footwear of the future will look like. Try sketching some space-age shoes.

❶ Start with a grid.

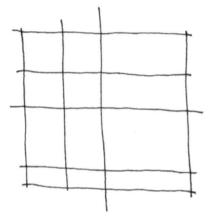

You can use this one to practice!

❷ Map out the shape.

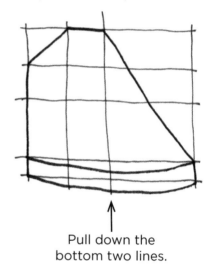

Pull down the bottom two lines.

❸

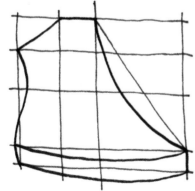

Create curves on either side.

❹

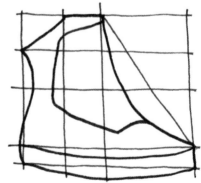

Add a patch on the front.

5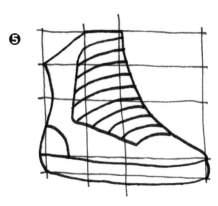

Add some details.

6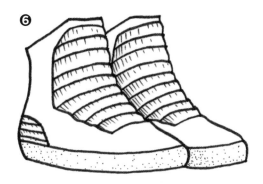

Duplicate to create a pair.

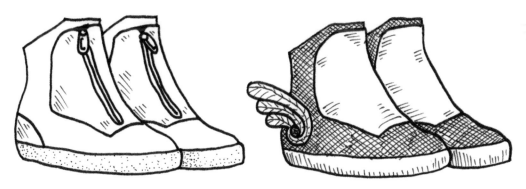

Try out some different variations—zips, Velcro, wings, jet packs...whatever you'd like your shoes of the future to feature. Use the space below.

Use these pages to sketch your space-age shoes...
or anything else from the future!

Your Home Is Your Castle

When we are done for the day and the world has been put to bed (and sometimes to rights), we can close the door on all the hustle and bustle and be safe and warm inside the kingdom that is our home. Let's think about the sketching we can do from the safety of our world.

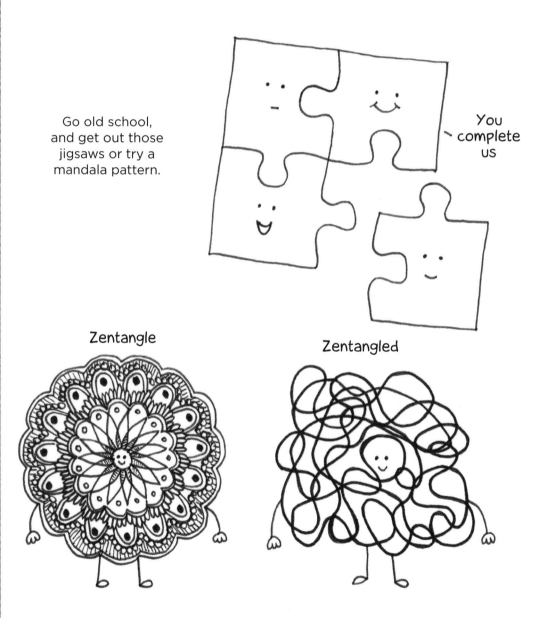

Go old school, and get out those jigsaws or try a mandala pattern.

You complete us

Zentangle

Zentangled

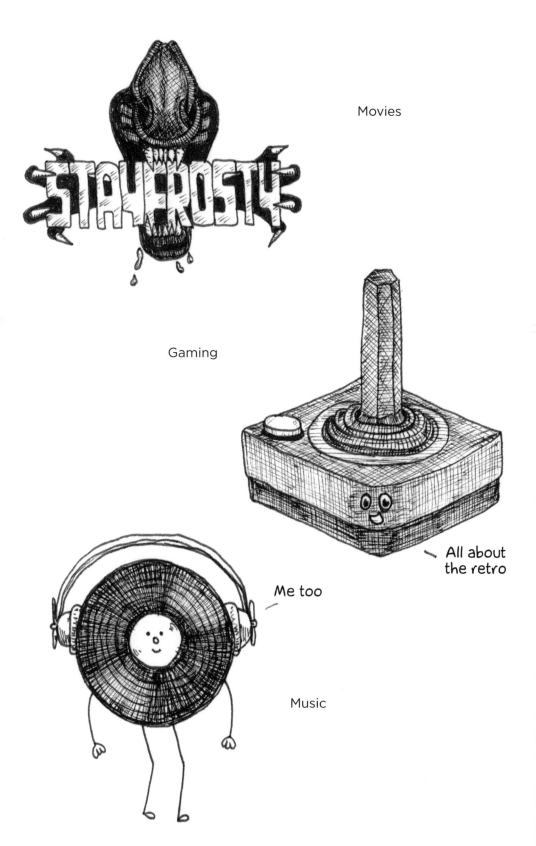

Movies

Gaming

All about
the retro

Me too

Music

Do you have a quiet nook where you like to curl up with a good book?

I love getting dirty

You disgust me

Or maybe you enjoy gardening or decorating your home.

Roll with it

We go together even though
we are different

I'm gonna cut
you to pizzas

If you don't want
to cook, order
takeout!

I'm glad you
think it's funny

Endless fun to be
had taking photos
of our pets...

Who are
you kidding

I'm so
Zen

However you like to spend
your home time, there are
a multitude of drawing
ideas to explore.

It won't
last

Think about your perfect night in
and sketch what you need here.

Wear Your Badge with Pride

In an age of social media, Internet forums, personal profiles, and emoticons, we inevitably find ourselves needing an avatar by which to be recognized. Of course, a photo of yourself is great for this, but what about a hand-drawn emoji—something unique and cartoony!

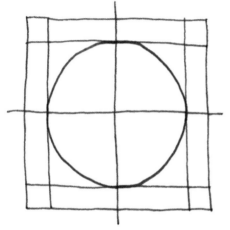

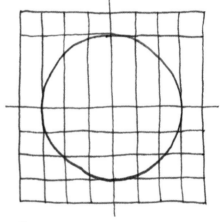

❶ Most avatars are square or round, so start there.

❷ Add some more grid lines as guides for facial features.

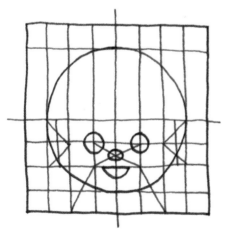

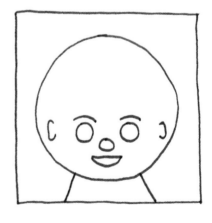

❸ Place the eyes, nose, and mouth. Add space for the ears at the top of the body.

❹ Here is the freaky-looking character, ready to be dressed.

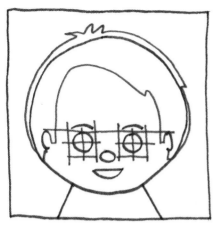

5 Since this is me, I need glasses and messy hair.

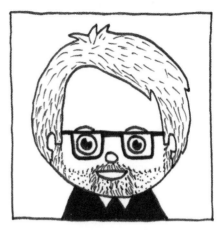

6 An unkempt beard, and I'm done. Hello!

Try out different facial expressions.

Add accessories.

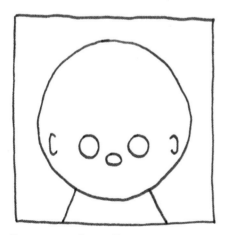

Draw your favorite you.

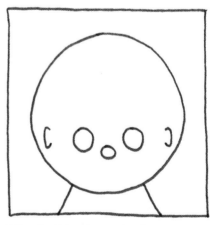

Who is this character?

Falling to Pieces

Even though we have an abundance of technology at our disposal, there is nothing more enjoyable than getting crafty when stuck in the house on a rainy Sunday afternoon. With this in mind, let's create a hand-drawn pattern, cut it up, and make a jigsaw. You'll need white card stock, drawing implements, a ruler, and a pair of scissors. (Seek supervision, if accident-prone, please.)

❶ Create a pattern using the happy blobs from page 29 of this book.

❷ I put faces on mine, but they could be eggs, scales, fingers, etc.

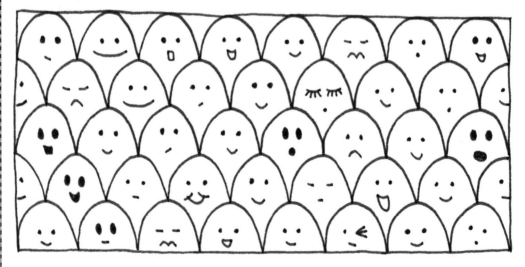

❸ When you're happy with your creation, turn it over and use your ruler to draw lines all over to create the puzzle. How small you make the pieces is entirely up to you! Then use the scissors to cut out the pieces.

❹ And there it is. The only thing left to do is put it back together. Try making detailed puzzles with lots of color, or cut up a pile of scribbles really small. The sky is the limit!

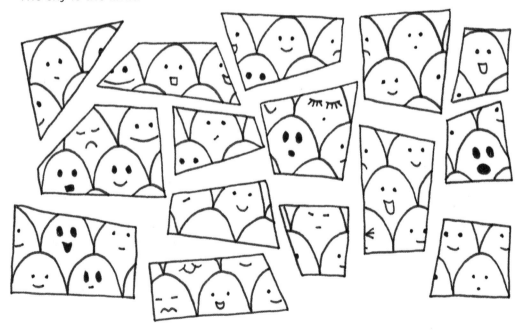

Movie Night

Everyone loves a good movie. Action movies with car chases and explosions, romantic comedies with your other half, Disney films with the kids (or without), slasher horror flicks with all the lights turned out, stories of distant galaxies and alien invasions—whatever your genre, there are movies for every taste. And so too, the snacks. You can't have movie night without popcorn.

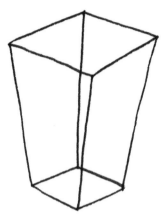

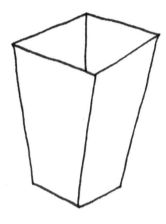

❶ Draw two squished squares, one smaller than the other.

❷ Join to create a tapered box.

❸ Erase unnecessary lines.

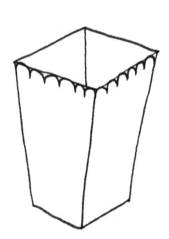

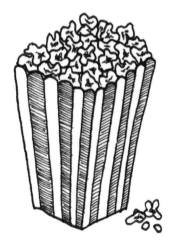

❹ Draw six semicircles on each side.

❺ Draw lines down to the base of the box.

❻ Add popcorn.

Draw some triangles.

Add the toppings.

Draw some ovals.

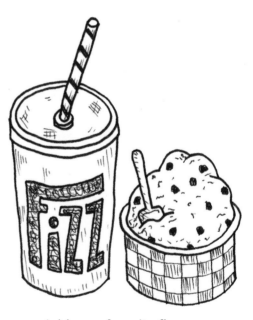

Add your favorite flavors.

What are your favorite snacks to enjoy on movie night? You could draw your food as movie characters, or even set up a scene or genre. For example, a horde of zombie hot dogs!

Taking a Line for a Walk

Doodles and scribbles. When you're a bit stuck for something to sketch, you can just draw some lines and turn them into something. No grids or templates for this! Just your drawing tools on an adventure.

❶ Draw a line, and then think of different ways to decorate it.

❷ Try doubling the line...

❸ Or loop the line...

❹ Or draw lines off the line.

You use these lines to decorate lists, make frames for invites, or customize name tags. Sketch some doodles on the lines below.

Me, Myself, and I

So, you're done for the day. All of life's chores are complete—or put off until tomorrow. The dishes are washed, the clothes are folded, the bills are paid, the kids have been walked, and the dogs are in bed. The doors are locked, the candles are flickering, and it's just you in your comfort cave. What are your favorite little pleasures? For me, it's TV, book sets, and chocolates.

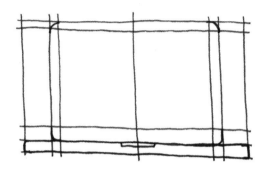

❶ Start with the now-famous grid.

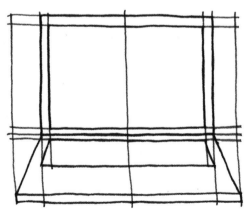

❷ Draw a simple laptop.

Or, be a little more adventurous and draw the laptop with a keyboard and touch pad.

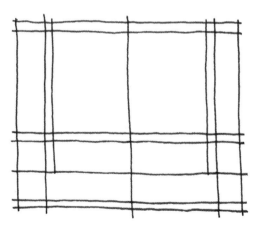

❸ Draw a more complicated grid.

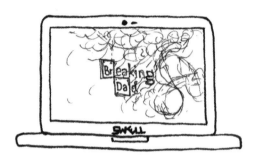

❹ Map out the laptop shape.

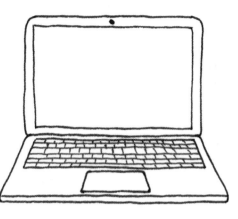

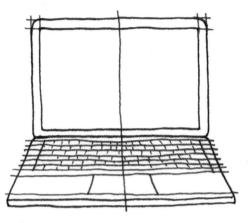

❺ Split the keyboard area into six parts and suggest keys. Add a touch pad.

❻ What are you watching?

Now add some chocolates to go with your TV binge.

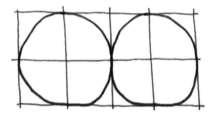

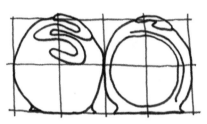

Draw two rough circles that are slightly flattened at the bottom.

Add a chocolate squiggle on top and cut one in half to show the center.

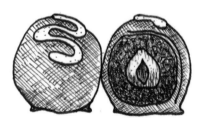

Hazelnut Praline

Banoffee Caramel

What are your favorites?

Create your own.

Use these pages to sketch more of your
favorite me-time activities.

Once You Start, You Can't Stop

As you can see from all the previous pages in the book, anything and everything can be a source of inspiration and sketching material, from the mundane to the fantastical. If you can imagine it, you can sketch it, scribble it, draw it, doodle it. Don't be surprised if you find yourself carrying a little sketchbook around and frantically scribbling little scenes as you go about your life.

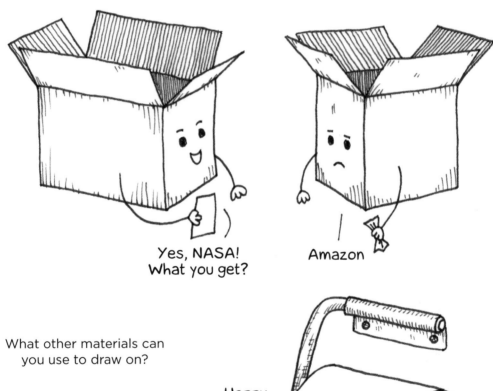

Yes, NASA!
What you get?

Amazon

What other materials can
you use to draw on?

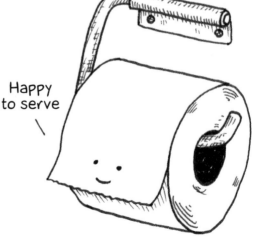

Happy
to serve

Let's be friends

Everything can be better with a couple of smiles, arms, and legs.

Try to inject some humor into your characters.

You Smell

Give in to the dark side

Never

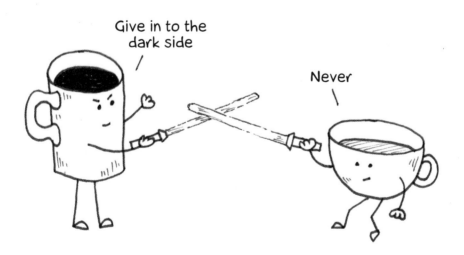

The most important thing is not to take your sketching too seriously, and have fun.

Although I would suggest never growing up, draw what you would like to be, just in case it ever happens.

Use these pages to sketch anything—
absolutely anything—you like.

Your Gallery

My Gallery

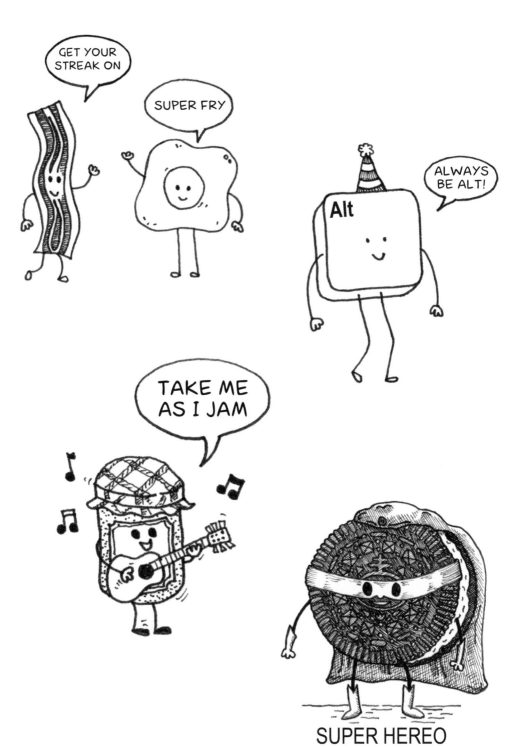

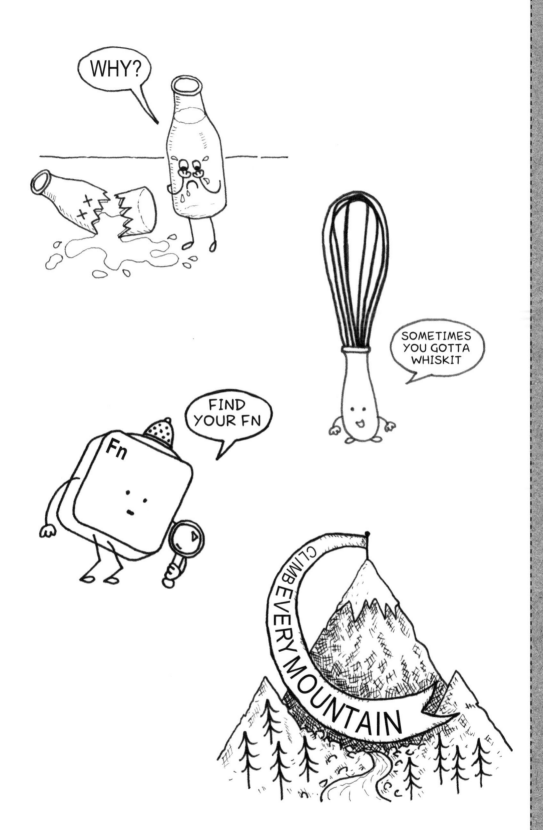

MAKE PEAS NOT WAR!

About the Artist

When Matt Andrews was five years old, he won an art competition for drawing stick horses. When he was in art college, he made prints with found objects and rude words—he didn't win any prizes, just a degree in fine art. Now that he's a grownup, he works in graphics, illustration, and media marketing. But most of the time, he can be found doodling funny characters on sticky notes and scraps of paper. He still draws stick horses.

Visit www.mattandrewsillustration.com to see more of his arty ramblings.